THE GREAT GOD PAN

THE GREAT
GOD PAN

THE SURVIVAL OF AN IMAGE

JOHN BOARDMAN

THAMES AND HUDSON

The Walter Neurath Memorial Lectures, up to 1992, were given at Birkbeck College, University of London, whose Governors and Master most generously sponsored them for twenty-four years.

British Library Cataloguing-in-Publication Data
A catalogue record for this book is available from the British Library

ISBN 0-500-55030-1

Printed and bound in Italy

Some thirty-three years ago I called on Walter Neurath and told him that I wanted to write a big book on Greek gems and finger rings. 'Ah, you want to rewrite Furtwängler.' 'No,' I said, 'no-one could do that; but I would like to bring up to date some of his chapters — they are seventy years old now — and to be as comprehensive as possible.' 'So' said he, 'you will want a lot of pictures; about 1,000?' I had hoped for 200. Within seconds Walter knew what the book should be about and what it ought to look like, better than I who had been thinking of writing it for years. I know I am not the only academic whose career and research has been substantially advanced by the wisdom and foresight of the founder of Thames and Hudson, and by the continuing support of his family. No university press that I know could be so encouraging and co-operative, nor would they have been so accommodating of a book that finished up with some 50,000 words of notes, and rather more than the promised 1,000 pictures. Sadly, Walter Neurath did not live to see my book published in 1970, and to give a lecture in his memory is but poor return for a publisher who virtually revolutionized the means for the study and appreciation of the history of art at all levels.

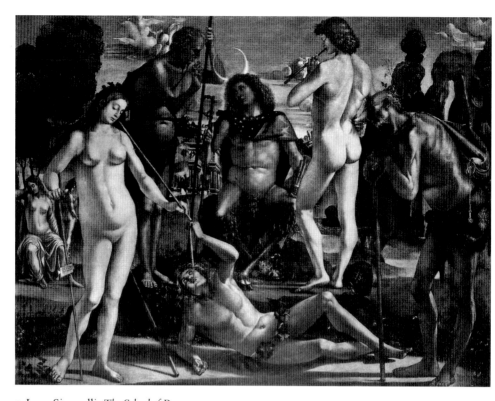

1 Luca Signorelli, *The School of Pan.*

What was he doing, the Great God Pan,
Down in the reeds by the river?

WE should probably better not enquire too closely. Elizabeth Barrett Browning's view of Pan was an idealized one of a literally tragic rustic deity embodying all the simple, if sometimes gross, pleasures of the countryside. In her husband's words, he was 'awful but kind'. But she could drop a tear for him too –

> *And that dismal cry rose slowly*
> *And sank slowly through the air,*
> *Full of spirit's melancholy*
> *And eternity's despair;*
> *And they heard the words it said –*
> *Pan is dead – great Pan is dead,*
> *Pan, Pan is dead.*

('A Musical Instrument', 1859)

However, all of us who keep our eyes and ears open know that Pan is not dead. Of all the gods and demigods of classical antiquity, beside perhaps Hercules, his image and reputation are the most readily recognized in the modern world. He has often been evoked to express much that seems relevant to various aspects of society and human behaviour, and in using him each author and artist commonly reveals more about themselves than about the god. So, before political correctness forbids us to continue enjoying our classical heritage in art and literature, I would like to devote the first part of this discussion to various aspects of Pan's career *since* antiquity; then to return to antiquity and the real Pan. I make no excuses for running together art, literature and life, and with such a subject I am bound to be highly selective and often recall the well familiar.

7

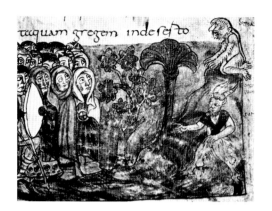

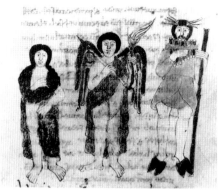

2 The Children of Israel, from the ninth-century Stuttgart Psalter, fol. 93v (Psalm 77).

3 Venus, Cupid and Pan, from a series illustrating the classical gods, in the eleventh-century Monte Cassino Codex 132.

In the Middle Ages, when Classical images were often translated into new Christian or allegorical identities and when Classical gods could be given modern dress, Pan often survived intact in appearance and function. In an illustration in the early ninth-century Stuttgart Psalter we find the Children of Israel, in modern dress, moving into an Egyptian wilderness peopled by a monkey, top right, and below it Pan, with his proper goat's horns and legs and clearly labelled [2].[1] He was still regarded as an appropriate denizen of the wild and shown as he would have been in antiquity. Later, in the early eleventh-century Monte Cassino MS of Hrabanus Maurus he remains recognizable – just – at the right beside a rather less probable Venus and Cupid [3].[2]

Thereafter we have to await the rediscovery of Pan and his fellow gods by the Italian Renaissance. Panofksy characterizes the change: 'The classical world ceased to be both a possession and a menace. It became instead the object of a passionate nostalgia which found expression in the re-emergence of that enchanting vision, Arcady. The Renaissance came to realise that Pan was dead – that the world of ancient Greece and Rome was lost like Milton's Paradise and capable of being regained only in the spirit.'[3]

8

One result was that Pan could be viewed with something of the idealizing fervour apparent in that earlier period of literary interest in him – the Hellenistic of the third and second centuries BC. Luca Signorelli's beautiful painting *The School of Pan*, destroyed in World War II, typifies the new mood [1]. In this work, painted for Lorenzo de' Medici. Pan holds court, a heroic but melancholy figure, with only his animal legs to betray the beast in him, a dignified expression of what we would all like to think of as the more spiritual yet potent aspects of classical antiquity. Michael Levey comments: 'There is something primeval and eternally classic in Signorelli's mysterious male and female nudes clustering about their god at twilight, banished creatures of mythology, who had always existed and who have now crept back in the welcoming Renaissance air.'[4]

From now on Pan becomes a familiar figure, with only a few uncertainties about his physique, a certain readiness for mutual contamination between Pan and satyrs, silens or fauns, such as we shall document also in antiquity. Andrea Riccio's bronze Pan listening to Echo is wholly human except for his tiny horns [5], but other bronzes introduce varieties in appearance and behaviour closer

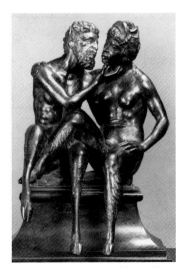

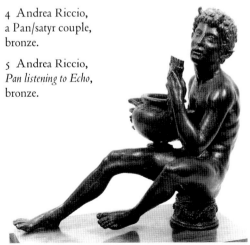

4 Andrea Riccio, a Pan/satyr couple, bronze.

5 Andrea Riccio, *Pan listening to Echo*, bronze.

to the usual ancient forms. Pan had multiplied also in classical antiquity and found his female counterpart. Another group by Riccio, although usually called 'satyr and satyress' [4],[5] portrays Pan in the normal Renaissance form, while their satyrs are often more wholly human. The girlish Pan or faun also long remains popular in European art. Choice of physique seems to have become a matter of personal taste, depending on whether the idyllic or the cruder and more bestial aspects of either the satyrs or Pan were to the fore. The satyrs' adoption of horns may be from Pan and, whatever the creatures are called, the horns bestow on the wearer aspects of the goat-god's behaviour as well as of his appearance.

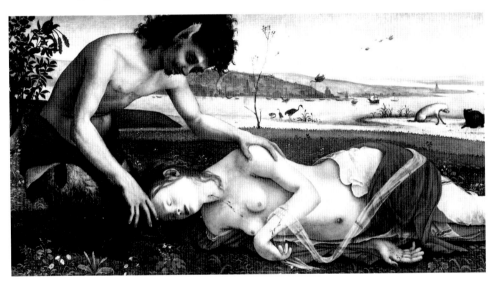

6 Piero di Cosimo, *A Mythological Subject* ('*The Death of Procris*'). Detail.

In Piero di Cosimo's painting *The Discovery of Honey* a thoroughly Dionysiac troupe of satyrs are shown with goats' legs [7],[6] and this is the physical form preferred by the artist for the nameless rustic demon in the more poignant setting of the so-called '*Death of Procris*' [6], as well as for other elemental figures in other paintings.

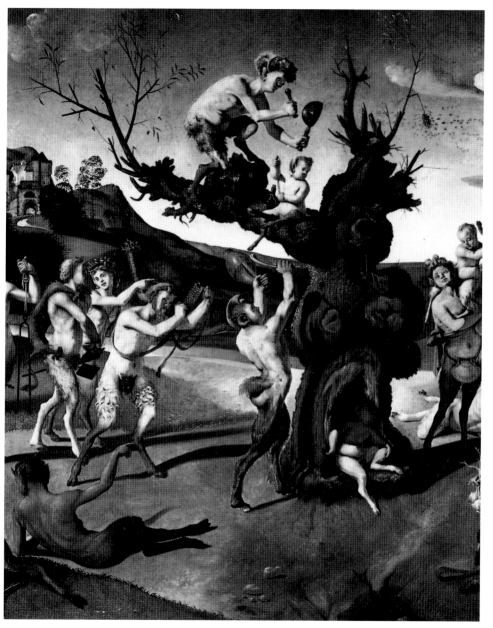

7 Piero di Cosimo, *The Discovery of Honey*. Detail.

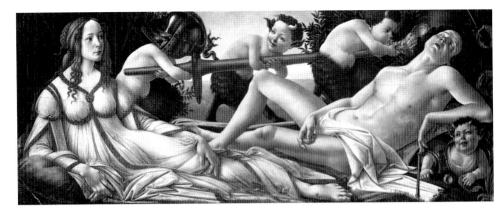

8 Sandro Botticelli, *Mars and Venus*.

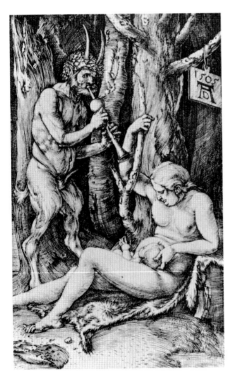
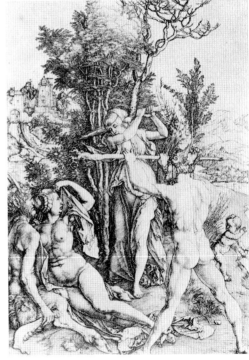

9 Albrecht Dürer, 'The Satyr's family', engraving.

10 Albrecht Dürer, 'Combat of Virtue and Pleasure before Hercules', engraving.

11 Annibale Carracci, Pan and Diana (Luna), detail of ceiling fresco in the Palazzo Farnese, Rome.

There were problems with baby Pans; in Botticelli's *Mars and Venus* they usurp the role of Cupids [8]. In classical art Pans can copy Cupids and satyrs in stealing the arms of Hercules, rather than those of Mars, while the scenes of Pan and a Cupid playing or wrestling together are not forgotten by Renaissance artists. Rather later, in Titian's *Bacchus and Ariadne* (1522–3), the grown satyrs are human, though shaggy-legged, but a baby Pan-like faun smugly intrudes in the foreground. In classical antiquity it was Pan who sometimes uncovered the sleeping Ariadne to Bacchus. For Poussin in *The Triumph of Pan* (1636) the god reverts to form for a Bacchanal revel. Dürer can offer an idyllic Pan-satyr family scene [9] and use the same figure as consort for a voluptuous figure of Vice being belaboured by Virtue, before a bewildered Herculean figure, unsure either of his choice or his policy of non-intervention [10].[7]

It would be easy, too easy, to prolong the catalogue of examples. I shall therefore add only one more – Annibale Carracci's colourful ceiling frescoes painted in the Galleria of the Palazzo Farnese in Rome (1597–1601). The overall theme is the loves of the gods, and

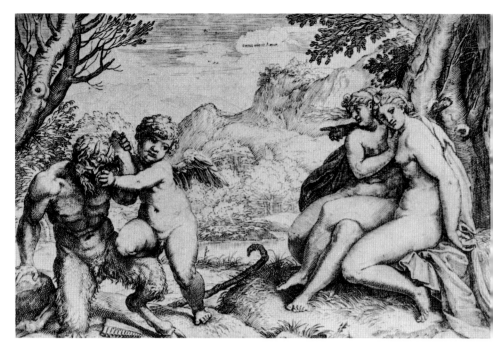

12 Agostino Carracci, *Omnia vincit Amor*, engraving.

the centrepiece has a triumphal procession of Bacchus and Ariadne.
Here, as on Roman sarcophagi, Pan lurks, preoccupied with a goat.
Scholars have sought to interpret the themes on the ceiling in terms of
a deliberate neo-Platonist exploration of the different types of love,
and agree generally on only one point – that Pan represents bestial
love. He reappears in different and sometimes appropriate places
elsewhere on the ceiling: pursuing the nymph Syrinx, who turns to
reeds; dazzling Selene or Diana with the whiteness of the fleece he
offers her [11];[8] and fighting Cupid, the theme we meet also in
antiquity, shown better here in an engraving by Agostino Carracci
[12],[9] in which the tiny motto in a cloud overhead identifies the scene:
Omnia vincit Amor – Love conquers all. In Greek 'all' is *pan*, hence –
following the false etymology of his name (explained below, pp. 26–7)
– Love conquers All = Love conquers Pan.

14

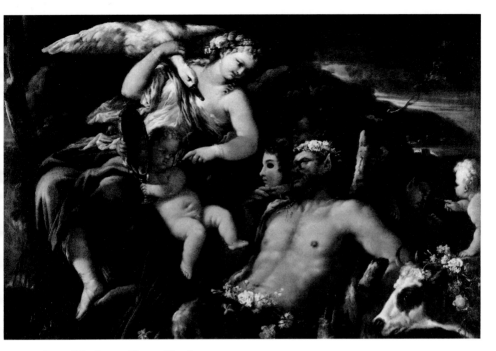

13 Luca Giordano, *Allegory*. Detail.

For the rest of modern Pan I have selected only a few themes that either give him a totally new persona, or develop aspects that have their roots in classical literature but not always classical art. One of the latter is Pan's ugliness. In a Hellenistic epigram he laments – 'Am I a goat deformed not only in leg but in heart too?' (Zeuxis VIII). He may be abused in ancient art, but not explicitly on account of his ugliness. This aspect, however, probably does underlie Giordano's *Allegory*, in which Pan is allowed to look at himself in a mirror, but only through the eyes of the mask with the features of a handsome youth held before his face by a second Cupid, while Venus with her anxious swan watches sympathetically [13].[10] According to antiquity, it was to disguise his uncouth body that Pan wrapped himself in fleecy white wool when wooing Diana. The subject, although created in antiquity, was never depicted by any ancient artist. We have seen

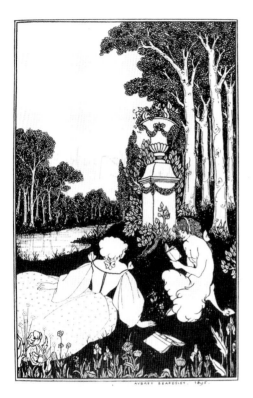

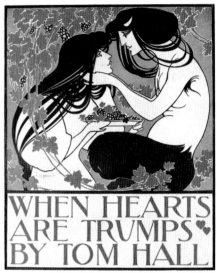

14 Aubrey Beardsley, catalogue cover, 1895.

15 W.H. Bradley, book cover for Tom Hall's *When Hearts are Trumps*, 1894.

WHEN HEARTS ARE TRUMPS ♥ BY TOM HALL

Carracci's treatment of the subject [11], and there were other versions by Italian artists, but these simply suggest that Pan offered her white wool, an unlikely bribe to lead to the seduction of a professional virgin like the moon goddess Diana/Luna.[11] So this subject is one that ancient artists ignored and that later artists probably misunderstood.

In Apuleius, Pan comforts Psyche in her vain search for Cupid (*Metamorphoses* V, 25, 3–6); again, not a subject for ancient art, but increasingly popular during the last two centuries in terms of Pan being compassionate to a young woman, not at all threatening, and often himself young. Among the many examples in art are: Burne-Jones in his *Pan and Psyche* [16] copying the composition of Piero di Cosimo's *'Procris'* [6],[12] a catalogue cover by Aubrey Beardsley [14],[13] and W.H. Bradley's cover for Tom Hall's book *When Hearts are Trumps* [15].[14] This aspect of Pan is even more generously treated in

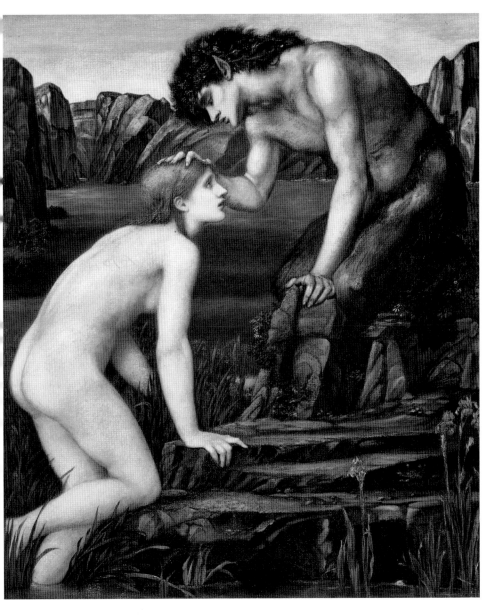

16 Edward Burne-Jones, *Pan and Psyche*.

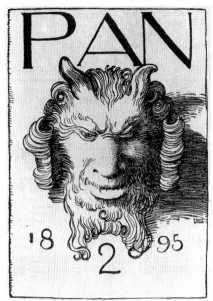
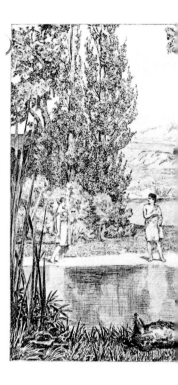

17, 18 Cover and illustration from
Pan, 1895.

literature. In J.K. Stephens' *The Crock of Gold* (1912), an essentially
Celtic tale, classical Pan is introduced to teach a young woman the
value of happiness, then sent off, in a friendly way, by the Celtic god
Angus Og. In a cinematic context, Woody Allen's *Manhattan* (1979),
the hero is given a harmonica, surely the modern equivalent of Pan
pipes, by his teenage mistress. The fact that he finds himself unable to
play the instrument recalls the ancient motif of Pan turning to town
life and forgetting his country skills, another literary theme:[15]

Here in the city will I dwell. Let someone else set forth to hunt the wild
beasts; Pan no longer lives his old life. (Meleager XCXXVI)

The wholly romanticized rustic Pan, musician and consort of
nymphs, occupies a world in which the modern imagination has also
outdone antiquity, where his rustic functions were on the whole
serious, and his love life either bestial or unrequited. At the turn of the

18

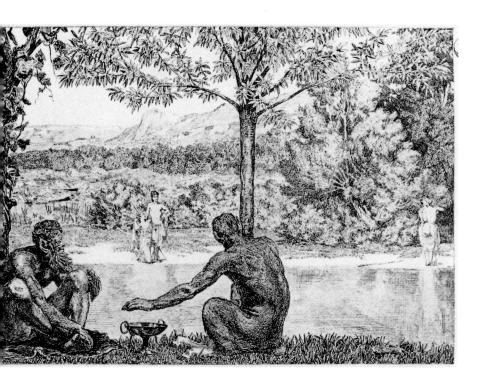

century there was a German art and culture periodical called *Pan*; in its early years it was rather full of Nietzsche and knights in armour, and the god appeared often in its pages as a heroized symbol of the clean, open-air artistic life of which its patrons dreamed. His head, as portrayed by the Bavarian artist Franz von Stuck, appears on its cover [17] and inside Pan is to be seen at the picnic in an idealized, at least semi-classical, sylvan setting [18]. Another periodical of the period, *Jugend*, repeats the rustic image; nothing but innocence here, no threat or insolence [19]. At a barely higher level the Swiss artist Arnold Böcklin painted idealized fantasies, including landscapes, and thus often found himself at home with figures from pagan mythology, notably Pan, as seen in his *Idylle* [21]. Franz von Stuck, who had a rather similar obsession, decorated his villa near Munich with a variety of original Pan images [20]. In Britain, Aubrey Beardsley captured the range of the Pan image, often borrowing from it to

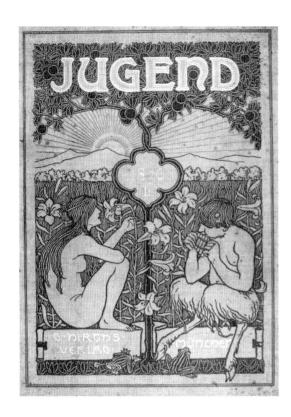

19 Title-page illustration from *Jugend*, 1896.

20 Franz von Stuck, *Dissonanz*, 1910.

enhance some of his more demonic creations, but well prepared to provide the idyllic view, as seen on a catalogue cover [14], though he himself was caricatured as Pan in *Punch* [23].

Something more mystic occurs in Kenneth Grahame's *Wind in the Willows* with Pan's intrusion as the Piper at the Gates of Dawn – a profoundly disturbing element in an otherwise charming rustic fable. We read of Rat and Mole in search of the lost baby otter, and of their sense of awe and terror. Mole 'raised his humble head; and then, in that utter clearness of the imminent dawn, while Nature, flushed with fullnesss of incredible colour, seemed to hold her breath for the event, he looked in the very eyes of the Friend and Helper; saw the backward sweep of the curved horns, gleaming in the growing daylight; saw the stern, hooked nose between the kindly eyes that were looking down on them humorously, while the bearded mouth broke

21 Arnold Böcklin, *Idylle*, 1875.

into a half-smile at the corners; saw the rippling muscles on the arm that lay across the broad chest, the long supple hand still holding the pan-pipes only just fallen away from the parted lips; saw the splendid curves of the shaggy limbs disposed in majestic ease on the sward; saw, last of all, nestling between his very hooves, sleeping soundly in entire peace and contentment, the little, round, podgy childish form of the baby otter … Then the two animals, crouching to the earth, bowed their heads and did worship.'

In the circumstances it is hardly surprising that Pan passed from art into life as well. Members of the Findhorn Community on the Moray Firth, devoted to the study and celebration of animate nature, know Pan well. Conversations with him in Edinburgh's Botanic Gardens and on Prince's Street have been published – 'As I turned the corner onto the street which runs alongside the National Gallery, I stepped

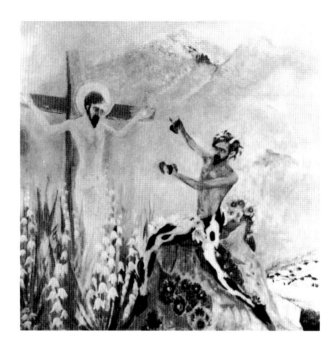

22 Dorothy Brett,
The Man who Died
(D.H. Lawrence), 1963.

into an extraordinary "atmosphere". . . . It produced a sensation of warmth and tingling like a mixture of pins and needles and an electric shock . . . Then I realised that I was not alone.' This took place in 1966.[16]

Otherwise it is Pan's amorous nature that has survived best. A hundred years ago there was a constant stream of novels and short stories in which he appears as countryman or even urban seducer. Later, he was very much taken up by the literati of Bloomsbury and their circle, and exploited in a literary way in caricatures of George Bernard Shaw [24], and even of D.H. Lawrence, the latter being presented as both a devil and Christ [22].[17] By now Pan has become a regular subject for cartoons and advertisements, especially those promoting tourism in Greece; he also serves – as the satyr did in antiquity – to personify the rather more relaxed or, if you like, animal aspects of human nature and, also like the satyr, is commonly found wanting. In a cartoon by Anton it takes no more than a goat's leg to invoke him [25].

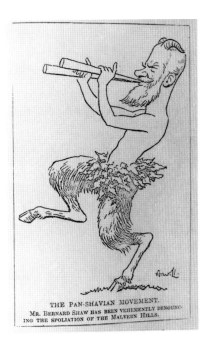

THE PAN-SHAVIAN MOVEMENT.
MR. BERNARD SHAW HAS BEEN VEHEMENTLY DENOUNC-
ING THE SPOLIATION OF THE MALVERN HILLS.

23 Aubrey Beardsley as Pan.

24 George Bernard Shaw as Pan.

25 Cartoon by Anton with the caption 'Perhaps that will convince
you that there's an orgy going on up there.'.

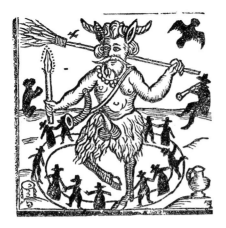

26 'The Mad Merry Pranks of Robin Goodfellow', Blackletter Ballad, seventeenth century.

There is only one other aspect of post-antique Pan to dwell upon – Pan as the Devil – and here we take the rather different viewpoints of artists and worshippers. Pan elements in the iconography of the Devil were rather inconsistently applied, but his reputation and behaviour were thought good qualifications for his service as model. The goat's head is not invariable and, whereas Renaissance Devils more often have the head of a pig than that of a goat, goats' horns are a regular feature and so are the animal legs. The tail is sometimes goatish, sometimes serpentine and pointed. The subject was one on which the artist preferred to work his own variations, and as long as Arcadian, rustic Pan remained in the repertory of artists the diabolical career of any Pan-like creature was not stressed. In Britain he was the inevitable model for a Robin Goodfellow [26],[18] but in the decoration on an English Delft tile the Devil figure that belabours Job is a Pan [29] In an early twentieth-century advertisement he supports his alter ego, Lucifer, a personification of the match [27].

There was another side to this, however, and in literature at least Pan could assume the role of Good Shepherd as readily as he could that of anti-Christ.[19] A sixteenth-century Englishman could write of 'Christ, the verye Pan and God of Shepheards',[20] and Milton writes more explicitly in his *Hymn on the Morning of Christ's Nativity*:

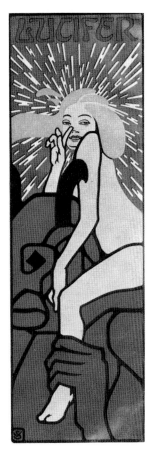

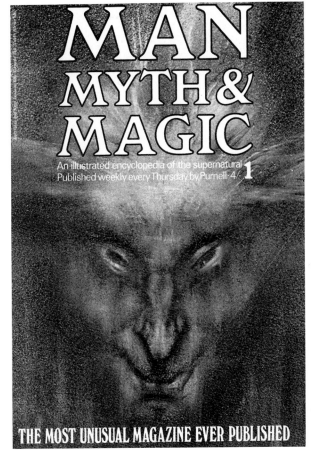

MAN
MYTH &
MAGIC

An illustrated encyclopedia of the supernatural
Published weekly every Thursday by Purnell · 4/- **1**

THE MOST UNUSUAL MAGAZINE EVER PUBLISHED

27 Victor Schufinsky,
Lucifer (match
advertisement), 1904.

28 *Man, Myth & Magic*,
cover illustration featuring a
detail of a pastel entitled *The
Vampires are Coming* (1955)
by Austin Osman Spare.

29 Job, decoration on an
English Delft tile.

The shepherds on the lawn
Or ere the point of dawn
Sat simply chatting in a rusticke row;
Full little thought they then
That the Mighty Pan
Was kindly come to live with them below.

In Europe, however, he had a far more real function as a Devil, and when we come to the cult of witchcraft he is very much in evidence, in witches' rites or ceremonies, down to Aleister Crowley's Club of Pan in Cambridge.[21] As recently as 1970, a new periodical entitled *Man, Myth & Magic* featured a cover picture – described as 'Portrait of a demonic elemental' [28] – by the late Austin Osman Spare, who had invented a method of conjuring up such creatures, but we all know who this is really.

* * *

We turn back to the land and antiquity which gave birth to Pan, to consider his appearance and career, to decide how far his later reputation and images were based on the stories, beliefs and images of classical antiquity.

First his parentage. Zeus and Apollo are often named as the father of Pan, but Hermes (Mercury) had the best claim by virtue of his generally rustic and good-shepherd character. In Greek mythology, Pan was a familiar of herdsmen and nymphs, he haunted the upland pastures and the shadowy places of siesta and his music was that of the countryman, just as his love life was decidedly bucolic. The god Hermes shared much of this nature, and he, like Pan, was at home in Arcadia, in southern Greece, where the cult of Pan probably began. For his mother we hear of the nymph Penelope, who could get confused with the wife of Odysseus and even give rise to the story – by the fact that the Greek word *pan* means 'all' – that he was fathered by the combined attentions of *all* her suitors. However, his name does not derive from the Greek *pan*, but comes from the root *pa-*, a contracted

30 Athenian black-figure vase (fragment), *c*. 490 BC.
31 Athenian black-figure vase (detail), *c*. 490 BC.

form of *pa-on* meaning herdsman; the same root is found in the English word 'pasture'. Nevertheless, in the *Homeric Hymn to Pan*, which is Classical in date and has nothing to do with Homer, he is called 'All' because the infant Pan pleased All the gods. In George Chapman's loud and bold translation:

> ... *monstrous to the eye,*
> *Goat-footed, Two-horned, full of noise even then ...*
> *Yet strait his mother start, and fled in feare*
> *The sight of so unsatisfying a thing,*
> *In whose face put forth such a bristled spring.*

Although Pan came to be confused with satyrs in antiquity as he did in the Renaissance, there was a basic difference, because the satyrs start as essentially human, and acquire animal features in varying degrees as time passes, while Pan starts as all animal. Various figures

27

of goats dancing upright in early Greek art, singly or in groups, could represent him; we cannot be sure, but on Athenian painted pottery we encounter him twice *c.* 490 BC. In one case he is shown upright and playing his pipes at a feast with Dionysos and Hermes (who appear on the couches beside him)[30];[22] here he is being acclimatized to an urban symposion, which is surprising, for this was not his natural setting. And in the second example, again upright, he accompanies a nymph [31].[23]

It is notable that Pan should already have been adopted thus in Athens, for it was in Athens that he shortly afterwards acquired a substantial place as a deity, far from his Arcadian home. While the Persians were invading Attica at Marathon, the runner Pheidippides was sent to Sparta to seek help. He reported that on his return journey he was accosted by Pan in Arcadia, and the god upbraided the Athenians for having ignored him. So, when all was well again, they built a shrine to Pan below their acropolis and held annual races and ceremonies in his honour (Herodotus VI, 105). What really happened is a matter for conjecture, but the results were clear; it has been suggested, for instance, that Pheidippides suffered 'altered consciousness' as a result of his prolonged running.[24]

So, it is not wholly because Athenian art is more familiar to us today that his image is best known from it, but we have still to trace the record of his translation from a wholly goat form into something that was at least part-human. This was easily achieved by Greek artists who were skilled at humanizing the bestial – think of their wholly plausible centaurs. Pan's relationship to the satyr has been remarked already. When Pan was still being represented as a goat, the satyr was mainly human, though with horse's ears and tail, and in some parts of Greece with hooves as well. The satyr shares with Pan an interest in music, but not rustic music, as well as in women and animals. The form which evolved for the satyr is demonstrated in Athenian art through the sixth century BC and helped determine classical Pan's physique. The physical relationship to a satyr is evident on a fourth-century BC vase, where Pan is seen dancing for one [32].[25]

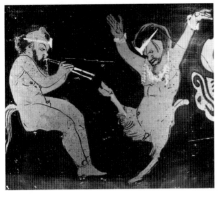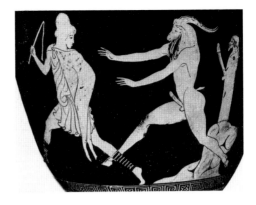

32 Pan dances for a satyr, Athenian red-figure vase, *c.* 400 BC.

33 Pan pursues Daphnis(?), Athenian red-figure vase by the Pan Painter, *c.* 470 BC.

Quite early examples give him a wholly human form, though often with a bestial head; by the end of the fifth century the classic type, with semi-bestial head and animal legs, has been contrived, but there had been, and continued to be, room for many variants. On the Pan Painter's name vase, a red-figure crater of *c.* 470 BC, he is shown chasing a passing yokel who has wandered too close to a rocky sanctuary dominated by a menacing Priapos [33]. Here is Beazley's description: 'A young goatherd in country garb . . . is hotly pursued by the goat god; and at the rock-seat a third, strange person, the wooden herm-like image of some small Priapos-like deity, views the scene with a round, bewildered eye . . . Here Pan has a goat's head, neck and horns, goat's hooves and a small goat's tail, but is otherwise human. The body is perfectly formed and proportioned, and the animal head has nobility; there is no other Pan in which the god shows so clearly through the goat.'[26]

There are many bronze statuettes of the period, especially from near his Arcadian home. In one example now in Berlin his head and neck are again animal, there is a hairy mane running down his spine and the legs are animal [34].[27] This is the Pan of the *Homeric Hymn* who

> . . . *climbs up and away through towering crags,*
> *For the topmost rocks to look down on the pasturing flocks.*

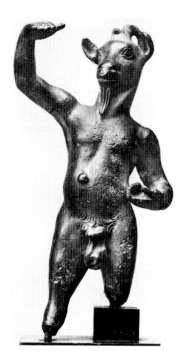

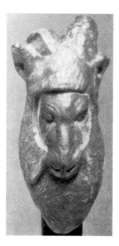

34 Bronze figure of
Pan, fifth century BC.

35 Bronze head of Pan,
terminal of a caduceus,
fifth century BC.

36 Bronze figure of Pan,
fifth century BC.

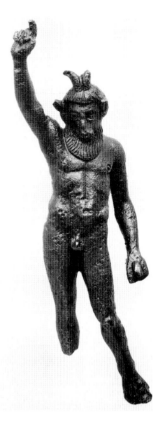

Having his hand raised to shade his eyes as he peers into the distance is
a pose that he often adopts: the Greeks of course had a word for it –
aposkopeuon.

Another bronze, found at Olympia, has Pan in more human form
again, with the physique of a Classical athlete but dancing and
snapping his fingers [36].[28] His feet are animal and his horned head
basically human except for the characteristic thickening overhang of
the nose by which the Classical artist bestialized his appearance. This
feature is perhaps first and best seen in a little bronze head from the end
of a wand found on the Athenian acropolis [35].[29] No later artist was
so successful in combining the human and bestial in this way, but here
he still has a human beard. Sometimes he is wrapped up against the
winter chill [38].[30] On rustic votive reliefs he was a regular onlooker,

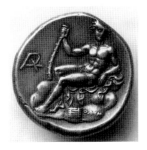

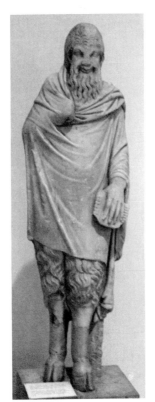

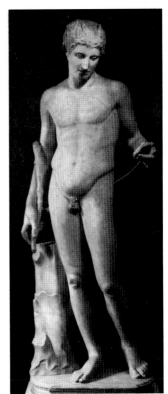

37 Silver stater of
Arcadia (reverse),
fourth century BC.

38 Pan, marble figure
from Sparta, c. 400
BC.

39 Pan, marble copy
of a fifth-century BC
original.

like his watery companion the river-god Acheloos, and he was entitled
to attend various mythological events located in the countryside and to
enjoy the company of the gods most associated with him.

Some Classical artists allowed him a truly Olympian physique.
The sculptor Polyclitus was probably responsible for devising a type
that was often copied in later years [39].[31] On early fourth-century
silver coins of Arcadia [37], the work of the die-engraver Olympios,
he relaxes on a rocky throne, a bit wild in the hair perhaps, but
otherwise divinely naked and as human as may be apart from the little
horns.[32] A reflection of Pan's respectability may be seen in the way
portraits of some Hellenistic rulers include horns, in what seems to
be a half-hearted assimilation to the god.[33] One of the subjects so
depicted, Antigonos Gonatas (c. 320–239 BC), was also lame.

31

Pan's attributes were the *lagobolon* throwing stick, a sort of one-directional boomerang, and his Pan-pipes, which are worth another look.[34] The pipes are a shepherd's instrument made of cut and bound reeds. The first examples in European art appear in the Alpine region, and in Greece we find them, played by a Muse, in the decoration on an Athenian vase made *c*. 570 BC.[35] Greek pipes have reeds of equal length, not graduated as later.

A multiplicity of Pans, even of women and children, was admitted in the classical period. Inasmuch as these imply a family life, Pan seems to have lost some measure of individuality. The multiple Pans were no doubt inspired by the multiple satyrs of Dionysos, who also become family men in the fifth century BC. On a fifth-century

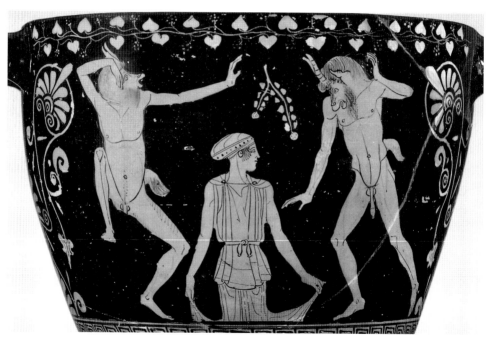

40 Two Pan demons greet the arrival of an earth goddess, red-figure vase by the Penthesilea Painter, *c*. 450 BC.

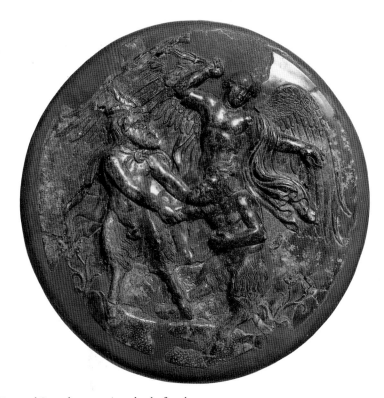

41 Eros and Pans, bronze mirror-back, fourth century BC.

vase by the Penthesilea Painter two Pan-like monsters attend the emergence of a goddess from the earth [40];[36] and on a later bronze mirror [41] Eros is shown breaking up a quarrel between two Pans.[37] From this time on it becomes possible to make contrasts between youthful, humanoid fully-grown Pans and the smaller and more familiar bearded and animal-legged demon, and even for the two to appear side by side, although it is not too easy to define the differences in character or function. Satyrs had no females, and as a source of inspiration for female Pans we might look to the alleged invention of female centaurs by the painter Zeuxis at the end of the fifth century. The first female Pan occurs about this time, on an engraved gem now

in Péronne [42].[38] She could hardly be more feminine, a graceful nude showing her mixed blood only in her tiny horns and tail, leaning on a rock playing with a bird or cup – it is not clear which. Later lady Pans conformed to the standard male type, as seen in a marble copy of a Hellenistic creation [43],[39] while on a Roman sarcophagus in the Museo Nazionale, Naples, they show no less interest in sexual matters than do their males.[40]

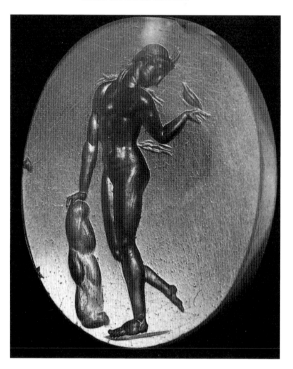

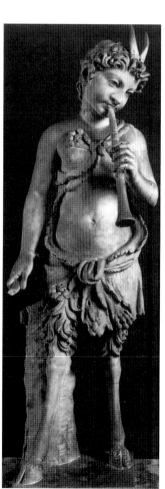

42 Girl Pan, chalcedony gem intaglio, c. 400 BC.

43 Girl Pan, marble copy of a Hellenistic original.

44 Pan at the hunt, fragment of an Athenian red-figure vase, fourth century BC.

Pan's country role was best expressed in poetry. He could personify the mellower, more congenial aspects of country life as well as its alarms and grossness. The siesta hour was sacred to him. Theocritus' goatherd sings:

Nay shepherd, nay; at noontide pipe we may not, for fear of Pan. For then of a surety he is resting wearied from the chase. And he is quick of temper and bitter wrath sits ever on his nostril. (*Idyll* I, 15–18; trans. Gow)

He was associated with another rustic phenomenon, the sudden madness which descends on a peaceful flock and sets goats and sheep racing over rocks and cliffs while the countryside echoes to their screams. They have been struck by Pan – quite literally panic-stricken, as were the Persians by his cry at Marathon.

His hunting is not much dwelt upon, but he did have an unfortunate encounter with a trap set by others, as depicted on a fourth-century Athenian vase [44], when he was badly snared in a sensitive spot.[41] His amorous interest in animals is not unexpected,

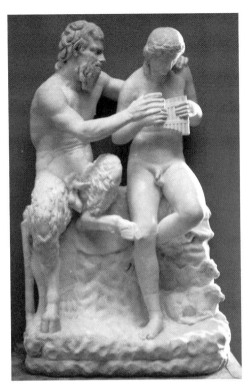

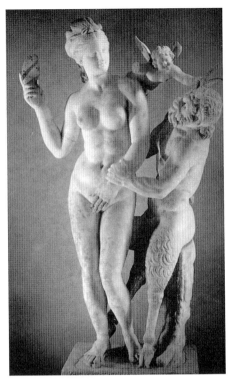

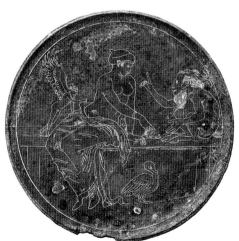

45 Pan and Daphnis, marble copy of a Hellenistic group, second century AD.

46, 47 Pan, Aphrodite and Eros, marble group from Delos, *c.* 100 BC; and detail.

48 Eros, Aphrodite and Pan, bronze mirror-cover from Corinth, fourth century BC.

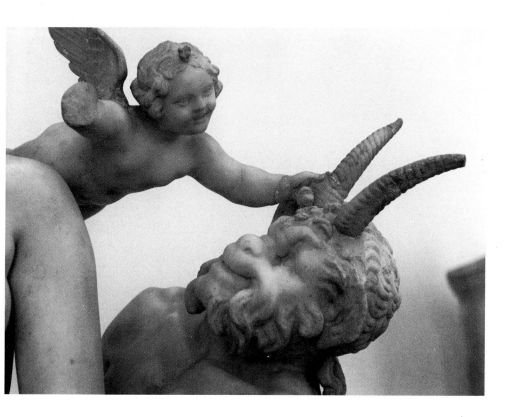

and he also chased boys in myth and in art, where he is shown teaching Daphnis or Olympos how to play the pipes [45].[42] In his relationships with women he had little luck; when they did not turn themselves into reeds or a tree in the nick of time, they were folk like the totally elusive nymph Echo.

He associated with several divinities, especially Aphrodite, and often on close terms. An unpleasant marble group now in the Athens Museum [46] was found in the House of the Posidoniasts of Beirut on Delos.[43] Its apparent theme, an assault rebuffed, seems obvious, but Pan is generally on friendly terms with her, and this figure may represent Aphrodite Pandemos or Epitragia, in her cruder form. She raises a sandal to slap him, but is this in anger or play? Overhead flutters Eros, playfully pushing, or is it pulling, at his horns [47]. Other evidence of Pan's good relations with Aphrodite appears on a

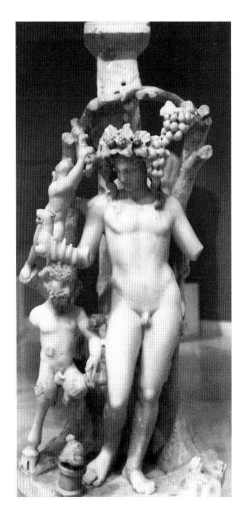

49 Dionysos and Pan, marble table-support from Asia Minor.

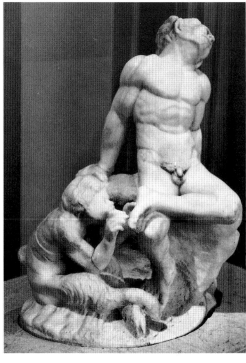

50 Pan removes a thorn from a satyr's foot, marble copy of a second-century BC original.

38

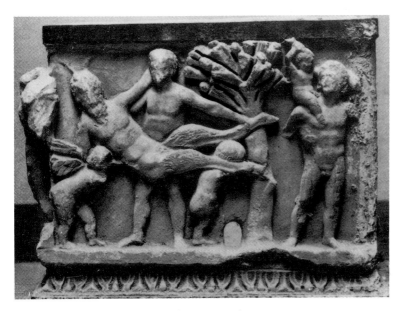

51 Pan removed by Cupids, sarcophagus, second century AD.

fourth-century bronze mirror from Corinth [48]; in this example he is seen crouching on a bench with her, arguing the toss over some point of the game of fivestones or jacks which they are playing, while Eros advises his mother.[44]

He has no less to do with Dionysos/Bacchus, for which we turn more to the arts of the early Roman Empire. He often supports the languid young god, as would a satyr, for example on a table-support from Asia Minor [49], and even relieves one of his satyrs of a thorn in the foot [50].[45] In Pompeian wall-paintings he uncovers the sleeping Ariadne for the god, but when he repeats the exercise only to discover that what he has found is a Hermaphrodite he recoils in dismay [52].[46] Pan joins the Bacchic rout on the same basis as any satyr in Roman art, but retains special functions. He was judged, however, to have had a weaker head for wine than any satyr, and on a sarcophagus of the second century AD he is shown having to be carried off by Cupids [51].[47]

39

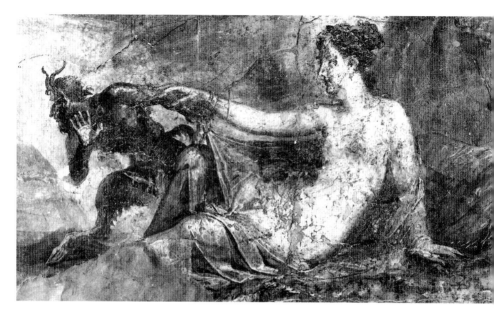

52 Pan uncovering a Hermaphrodite, detail of a wall-painting from Pompeii, first century AD.

His worst mistake is described by Ovid: Heracles and Omphale were resting in a cave, the hero having exchanged clothes with the Lydian queen. When a Roman Pan, as Faunus, comes upon them, he tries to ravish what he took to be the woman (*Fasti* 2, 305–58).

Away from the Classical world his image proved far less potent than that of a Hercules.[48] Finally, any review of Pan in antiquity must present him at his noblest: this aspect is reflected in a Pompeian wall-painting which recaptures the dignity of the classical, mainly human Pan in a setting of muses and music [53][49] and in its way anticipates Signorelli [1].

It was only in the Roman period that the false etymology of his name lent Pan the character of the God of All, a pantheistic figure, but this had little effect on his worship or the way he was depicted; yet that most dire episode in his career – his death – had already taken

40

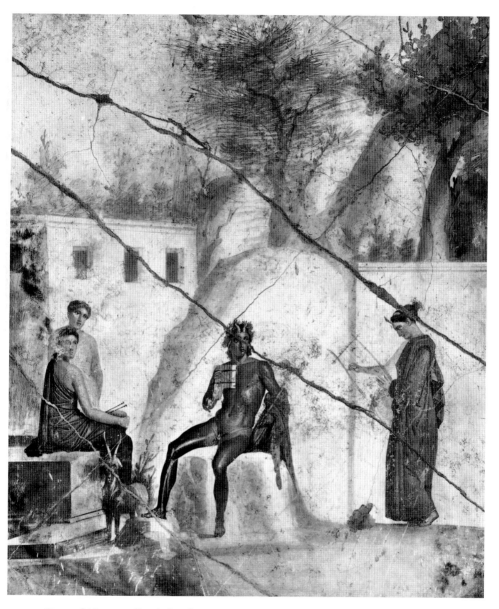

53 Pan and Muses, wall-painting from Pompeii, first century AD.

place.[50] Plutarch tells the story of the event which happened during the reign of the Emperor Trajan (98–117):

A teacher tells how . . . once upon a time in making a voyage to Italy he embarked on a ship carrying freight and many passengers. It was already evening when, near the Echinades Islands, the wind dropped, and the ship drifted near Paxi. Almost everybody was awake and a good many had not finished their after-dinner wine. Suddenly from the island of Paxi was heard the voice of someone loudly calling Thamus, so that all were amazed. Thamus was an Egyptian pilot, not known by name even to many on board. Twice he was called and made no reply, but the third time he answered; and the caller, raising his voice, said, 'When you sail by Palodes, announce aloud that Great Pan is dead.' On hearing this, all were astounded and reasoned among themselves whether it were better to carry out the order or refuse to meddle and let the matter go. Under the circumstances Thamus made up his mind that if there should be a breeze he would sail past and keep quiet, but with no wind and a calm sea he would proclaim what he had heard. So when he came opposite Palodes and there was neither wind nor wave, Thamus, from the stern, looking towards the land, said the words as he had heard them – 'Great Pan is dead'. Even before the last word had left his lips there arose from the island a great cry of grief not of one person but of many, mingled with exclamations of dismay. (*de defectu oraculorum*, 419b-e)

Explanations for this *alleged* episode, as we have to describe it, have occupied scholars and men of god since antiquity. Some see in the cry to the steersman not his own name, Thamus, but Tammuz, the eastern name for Adonis, and in the words *Pan megiste*, not 'Great Pan' but an epithet for Adonis, 'all-greatest'; and so the cry could have been borrowed from the mystery cult of Adonis and have nothing to do with Pan. The event described took place not long after the death of Jesus, and this dramatic announcement of the death of a universal deity was taken either in connection with the death of Christ or with the overthrow of the Devil. If we turn back to Milton's *Hymn on the Morning of Christ's Nativity*, it is exactly this image of sorrowing nature which he uses to describe the decline of the pagan gods at the coming of the true God:

42

The lonely mountains oer,
And the resounding shore
 A voice of weeping heard and loud lament;
From haunted spring and dale
Edged with poplar pale,
 The parting genius is with sighing sent;
With flower-inwoven tresses torn,
The nymphs in twilight shade of tangled thickets mourn.
 (Str. XX, 181–3)

And the image of mourning animate nature recurs in *Paradise Lost* as Eve eats the apple:

Nature . . .
Sighing through all her works, gave signs of woe
That all was lost (IX, 782–5)

It is of course the same image which Mrs Browning used:

. . . that dismal cry rose slowly
And sank slowly through the air,
Full of spirit's melancholy
And eternity's despair;
And they heard the words it said –
Pan is dead – Great Pan is dead,
Pan, Pan is dead.

Her view of the event finds in it a portent of the approaching end of the pagan classical world, in which one might rejoice, as in the passage from darkness to light; or for which one might mourn, since it marked the passing of the simple, if sometimes violent, Arcadian life – where Pan, his pipes and cry, could soothe or terrify the hearts of man and beasts, and where the god himself suffered the agonies of his ugliness and love – and the arrival of a modern world in which Pan could be remembered only as a symbol, either of lost rustic innocence or of the most basic and deeply felt passions of that noblest of animals, Man.

43

NOTES

Principal sources:

W.H. Roscher and K. Wernicke, 'Pan', in *Ausführliches Lexikon der griechischen und römischen Mythologie* III (1897–1909), 1347–1481

F. Brommer, 'Pan' in *Real-Encyclopädie der classischen Altertumswissenschaft* Suppl. 8 (1956), 949–1008; a closely documented survey

Lexicon Iconographicum Mythologiae Classicae I–VIII (1981–97); 'Pan' by J. Boardman is in vol. VIII (1997), 923–41, with references and illustrations for Pan in antiquity. Hereafter *LIMC*

R. Herbig, *Pan* (1949); a detailed essay

P. Merivale, *Pan the Goat God: His Myth in Modern Times* (1969); a full account of Pan mainly in Western literature

N. Marquardt, *Pan in der hellenistischen und kaiserzeitlichen Plastik* (1995)

J.D. Reid, *Oxford Guide to Classical Mythology in the Arts 1300–1990s* (1993): 'Pan', 802–13; lists

1. E. Panofsky, *Renaissance and Renascences in Western Art* (1965), fig. 63. The name Pan appears in the margin.
2. N. Himmelmann, 'Antike Götter im Mittelalter', in *7. Trierer Winckelmannsprogramm 1985*, 1–22, pl. 4,2.
3. Op. cit. (n. 1), 113.
4. Michael Levey, *Early Renaissance* (1967), 171.
5. M. Levey, op. cit., 90, fig. 46. *Italian Bronze Statuettes* (exhibition catalogue), V&A Museum (1961), no. 55.
6. On Piero di Cosimo in this context, E. Panofsky, *Studies in Iconology* (1939), ch. 2, with pl. 31, cf. pls. 27, 32.
7. E. Panofsky, *Albrecht Dürer* (1945), 'Satyr's Family', no. 176, fig. 123; 'Combat of Virtue and Pleasure in the Presence of Hercules', no. 80, fig. 108.
8. J.R. Martin, *The Farnese Gallery* (1965), pls. 51 (Syrinx), 65 (Diana), 69 (Triumph of Bacchus), 276 (with Eros); cf. 48, 67–8. I. Marzik, *Das Bildprogramm der Galleria Farnese in Rom* (1986), 192–6, fig. 66.
9. D. De Grazia, *Le Stampe dei Carracci* (1984), no. 210, fig. 237.
10. Painted *c.* 1675. See U. Hoff (ed.), *European Paintings before 1800 in the National Gallery of Victoria* (ed. 3, 1995). O. Ferrari and G. Scavizzi, *Luca Giordano* (1992), no. A256a, fig. 334.
11. The prime source is Virgil, *Georgics* 3, 391–3, explained in Servius, ad loc., citing Nicander (third century

44

BC) as source, . . . *niveis velleribus se circumdedit . . .* Cf. R.A.B. Mynors, *Virgil. Georgics* (1990), 238–9. For the Renaissance treatment of the subject, taking the wool as a gift, E. McGrath, 'Pan and the Wool' in *The Ringling Museum of Art Journal* (1983), 52–65 (I am indebted to T. Wilson for the reference). For an example in maiolica, where the 'wool' can only be the exiguous cloak a greybeard Pan wears, see *Journal of the History of Collections* 8 (1996), 178. The general motif appears in other stories, with various connotations (e.g. 'sheep's clothing'). There is one unusual parallel in antiquity. Herodotus (2, 42) says that at Mendes in Egypt 'Zeus' would only show himself to 'Hercules' wrapped in a ram's skin and with a ram's head; whence the horned Zeus Ammon; and the animal god of Mendes is equated with Pan (ibid., 2, 46).

12. M. Harrison and B. Waters, *Burne-Jones* (1973), 116, fig. 150.

13. *The Later Works of Aubrey Beardsley* (1901), no. 76.

14. William H. Bradley, 1894; book cover. *Apollo* (1970), 201, fig. 9.

15. For another film association, R. Payne, *The Great God Pan* (1952), a study of Charlie Chaplin; and Jean Renoir's film *Le Déjeuner sur l'Herbe* (1964). Merivale's book is a vital source for references and discussion of the use of Pan in English literature.

16. *The Findhorn Garden* (by the Findhorn Community, 1975), quotation from p. 104 (R.O. Crombie). P. Hawken, *The Magic of Findhorn* (1975).

17. Merivale, fig. 16 (*Punch*, 1929); fig. 15 (by Dorothy Brett).

18. Merivale, fig. 4.

19. Early Good Shepherds are thought to have borrowed Pan's *syrinx*; R. Birisjoly in *Tranquillitas* (Mélanges, Tran Tam Tinh, 1994), 75–81.

20. Gloss. Spenser's Shepherds' Calendar (1579).

21. In 1974 two men accused of arson were acquitted at Highgate Magistrates Court; they claimed in their defence that they had been worshipping Pan (*The Guardian*, 7 March).

22. *LIMC*, 'Pan' no. 4.

23. *LIMC*, 'Pan' no. 3.

24. W.F. Forehand, *The Classical Outlook* 63 (1985) 1–2.

25. *LIMC*, 'Pan' no. 212.

26. *LIMC*, 'Daphnis' no. 1. J.D. Beazley, *Attic Vase Paintings in Boston* II (1954), 46, 48

27. *LIMC*, 'Pan' no. 8.

28. *LIMC*, 'Pan' no. 33.

29. *LIMC*, 'Pan' no. 6; 'Kerykeion' no. 17.

30. *LIMC*, Pan no. 101.

31. *LIMC*, 'Pan' no. 47.

32. *LIMC*, 'Pan' no. 274.

33. H.P. Laubscher, *Athenische Mitteilungen* 100 (1985), 333–53.

34. G. Haas, *Die Syrinx in der griechischer Bildkunst* (1985).

35. On the François Vase (Florence, Mus. Arch. 4209), P.E. Arias, M. Hirmer and B.B. Shefton, *History of Greek Vase Painting* (1962), pl. 40 (shoulder, towards the left, a facing figure).

36. *LIMC*, 'Aphrodite' no. 1158.

37. *LIMC*, 'Pan' no. 135.

38. *LIMC*, 'Pan' no. 69.

39. *LIMC*, 'Pan' no. 70.

40. Naples, Museo Nazionale 27710, sarcophagus; *LIMC*, Pan no. 68; one

offers herself to a bearded herm, the other is assaulted by a young Pan.

41. *LIMC*, 'Pan' no. 247.
42. *LIMC*, 'Daphnis' no. 8b.
43. *LIMC*, 'Aphrodite' no. 514.
44. *LIMC*, 'Aphrodite' no. 1343.
45. T. Stephanidou-Tiveriou, *Archaiologike Ephemeris* (1989), 39–66. *LIMC* 'Pan' no. 213.
46. *LIMC*, 'Pan' no. 163.
47. *LIMC*, 'Pan' no. 222 and cf. nos. 223–5.
48. Earlier, he is equated with the Egyptian phallic god Min: N. Lewis, *Life in Roman Egypt* (1983), 85 and *LIMC*, Pan no. 291, and more generally in Herodotus (2, 46, cf. 145). Exceptionally, I have noted a Pan *aposkopeuon* in the corner of a schist relief from Hadda in the Kabul Museum (where it may not have survived the recent troubles in Afghanistan).
49. *LIMC*, 'Pan' no. 197.
50. P. Bourgeaud, in *Revue de l'Histoire des Religions* 200 (1983), 3–39, for a general study.

LIST OF ILLUSTRATIONS

1 Luca Signorelli (1441–1523), *The School of Pan*. Formerly Kaiser-Friedrich Museum, Berlin; destroyed during World War II.

2 The Children of Israel, from the ninth-century Stuttgart Psalter, fol. 93v (Psalm 77). Württembergische Landesbibliothek, Stuttgart MS Biblia Folia 23.

3 Venus, Cupid and Pan, from a series illustrating the classical gods. Monte Cassino Codex 132. Hrabanus Maurus. Eleventh century. Foto Biblioteca Vaticana.

4 Andrea Riccio (*c.* 1470–1532), '*Satyr and Satyress*', bronze. The V&A Picture Library, London.

5 Andrea Riccio (*c.* 1470–1532). *Pan listening to Echo*, bronze. Ashmolean Museum, Oxford.

6 Piero di Cosimo (*c.* 1462–1521). *A Mythological Subject* ('*The Death of Procris*'), oil on wood. The National Gallery, London.

7 Piero di Cosimo (*c.* 1462–1521). *The Discovery of Honey* (detail), tempera on wood. Worcester Art Museum, Worcester, Massachusetts 1937.76.

8 Sandro Botticelli (1445-1510), *Mars and Venus*, oil on wood. The National Gallery, London.

9 Albrecht Dürer (1471–1528), 'The Satyr's family', engraving (32.3 x 22.3 cm).

10 Albrecht Dürer (1471–1528), 'Combat of Virtue and Pleasure before Hercules', engraving (11.6 x 7.1 cm).

11 Annibale Carracci (1560–1609), *Pan and Diana*, detail of ceiling fresco, Palazzo Farnese, Rome. Gabinetto Fotografico Nazionale, Rome.

12 Agostino Carracci (1557–1602), *Omnia vincit Amor*, engraving.

13 Luca Giordano (1634–1705), *Allegory* (detail). National Gallery of Victoria, Melbourne E1/1988.

14 Aubrey Beardsley (1872–98). Catalogue cover, 1895.

15 W.H. Bradley, cover for *When Hearts are Trumps* by Tom Hall, 1894.
16 Edward Burne-Jones (1833–98), *Pan and Psyche*, 1874. Courtesy of the Fogg Art Museum, Harvard University Art Museums, Cambridge, Massachusetts 1943.187 (Grenville L. Winthrop Bequest).
17 Cover from *Pan*, 1895.
18 Illustration from *Pan*, 1895.
19 Title page from *Jugend*, 1896.
20 Franz von Stuck (1863–1928). *Dissonanz*, 1910. Museum Villa Stuck, Munich.
21 Arnold Böcklin (1827–1901), *Idylle*, oil on canvas, 1875. Schack-Galerie, Bayerische Staatsgemälde-sammlungen, Munich.
22 Dorothy Brett (1883–1977), *The Man Who Died* (D.H. Lawrence), oil on wood, 1963. Eugene B. Adkins Collection, Tulsa, Oklahoma.
23 Aubrey Beardsley as Pan. *Punch* 109 (1895), p. 35. Reproduced with permission of Punch Ltd.
24 George Bernard Shaw as Pan. *Punch* 177 (1929), p. 438. Reproduced with permission of Punch Ltd.
25 Cartoon by Anton (1912–70). By permission of Elizabeth Yeoman.
26 'The Mad Merry Pranks of Robin Goodfellow', Blackletter Ballad, seventeenth century.
27 Victor Schufinsky, Lucifer (match advertisement), 1904.
28 Cover illustration for *Man, Myth & Magic*, 1 (1970), featuring a detail of a pastel, *The Vampires are Coming*, by Austin Osman Spare (1886–1956); the work is reproduced in full in Kenneth and Steffi Grant, *Zos Speaks: Encounters with Austin Osman Spare*. By permission of Kenneth Grant.

29 Job, decoration on an English Delft tile. Author's collection. Photo R.L.Wilkins.
30 Pan pipes for a symposion, fragment of an Athenian black-figure crater, *c.* 490 BC. Allard Pierson Museum, Amsterdam 2117/8.
31 Pan and a nymph, detail of an Athenian black-figure amphora, *c.* 490 BC. South Africa Museum, Cape Town.
32 Pan dances for a satyr, detail of an Athenian red-figure crater, *c.* 400 BC. Museo Provinciale, Lecce 773.
33 Pan pursues Daphnis(?), Athenian red-figure crater by the Pan Painter, *c.* 470 BC. James Fund and by Special Contribution. Courtesy Museum of Fine Arts, Boston, Massachusetts 10.185.
34 Bronze figure of Pan from Lusoi, fifth century BC. Staatliche Museen, Berlin 8624. Photo Preussischer Bildarchiv.
35 Bronze head of Pan, terminal of a caduceus from the Athenian Acropolis, fifth century BC. National Archaeological Museum, Athens 409.
36 Bronze figure of Pan, fifth century BC. Olympia Archaeological Museum B 1601. Photo DAI, Athens.
37 Pan, silver stater of Arcadia, signed by the engraver Olympios, fourth century BC. Cabinet des Médailles, Paris. Cliché © La Bibliothèque Nationale de France.
38 Pan, marble figure from Sparta, *c.* 400 BC. National Archaeological Museum, Athens 252. Photo the author.
39 Pan, marble copy of a fifth-century BC original. Rijksmuseum van Oudheden, Leiden PB98.

40 Two Pan demons greet the arrival (*anodos*) of an earth goddess, Athenian red-figure vase by the Penthesilea Painter, *c.* 450 BC. Henry Lillie Pierce Fund. Courtesy Museum of Fine Arts, Boston, Massachusetts 01.8032.

41 Two Pans fight before Eros, bronze relief mirror-back, fourth century BC. Metropolitan Museum of Art, New York, Rogers Fund, 1907 (07.259).

42 Girl Pan, chalcedony gem intaglio, *c.* 400 BC. Musée Danicourt, Péronne (Somme). Photo R.L.Wilkins.

43 Girl Pan piping, marble copy of a Hellenistic original. Galleria Albani e Collezione Archeologica, Rome 997.

44 Pan at the hunt, his penis caught in a trap, fragment of an Athenian red-figure vase from Montlaurès, fourth century BC. Musée Archéologique et Préhistorique, Narbonne 36.1.128.

45 Pan teaches Daphnis to play the pipes, marble copy of a Hellenistic group, second century AD. Petworth House, Sussex. Photo the author.

46, 47 Pan, Aphrodite and Eros, marble group from Delos (and detail), *c.* 100 BC. National Archaeological Museum, Athens 3335. Photo the author (47).

48 Aphrodite and Pan play jacks; Eros watches. Bronze mirror-cover from Corinth, fourth century BC. Copyright British Museum, London 289.

49 Dionysos and Pan, marble table-support from Asia Minor. National Archaeological Museum, Athens 5706. Photo the author.

50 Pan removes a thorn from a satyr's foot, marble copy of a second-century BC original. Musée du Louvre, Paris MA 3250. Photo the author.

51 Pan removed from the feast by Cupids, sarcophagus, second century AD. S. Scolastica, Subiaco.

52 Pan uncovering a Hermaphrodite, wall-painting from Pompeii, first century AD. Museo Archeologico Nazionale, Naples 27711.

53 Pan and Muses, wall-painting from Pompeii, first century AD. Museo Archeologico Nazionale, Naples 11147.